# Stumpwork
# Figures

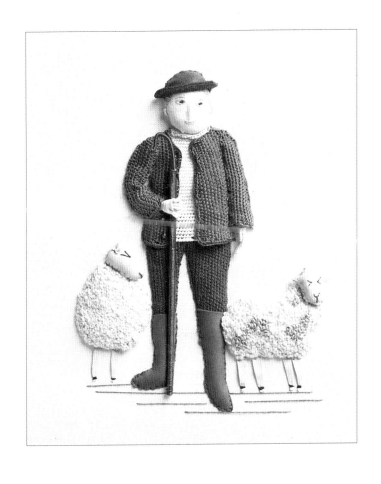

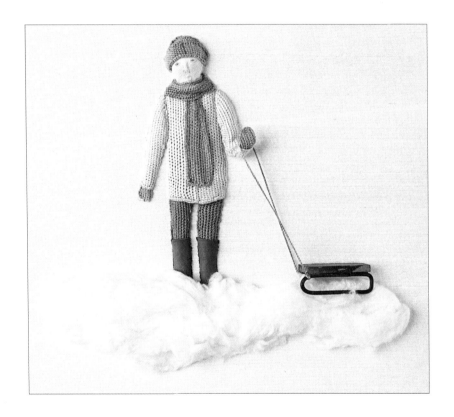

# Stumpwork Figures

Kay & Michael Dennis

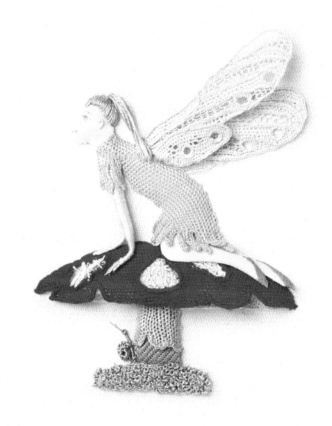

SEARCH PRESS

First published in Great Britain 2006

Search Press Limited
Wellwood, North Farm Road,
Tunbridge Wells, Kent TN2 3DR

Text copyright © Kay Dennis and Michael Dennis 2006

Website: www.kaydennis.co.uk

Photographs by Search Press Studios
Photographs and design copyright © Search Press Ltd.

ISBN 1 84448 087 9

**Suppliers**
If you have difficulty in obtaining any of the materials and
equipment mentioned in this book, please visit the Search Press
website for details of suppliers: www.searchpress.com
Alternatively, you can write to the Publishers at the address
above, for a current list of stockists, including firms which operate
a mail-order service.

**Publishers' note**
All the step-by-step photographs in this book feature
the authors, Kay and Michael Dennis, demonstrating
stumpwork techniques. No models have been used.

## Acknowledgements

*We would like to thank the team at Search Press, especially
Roz, Katie and Lotti. We would also like to thank Rebecca
Balchin for allowing us to use her fairy designs, Neil and
Patricia Wood of Mulberry Silks, Jane and Sarah Jane of
Threads of Amersham, and Bob Weston for the needlelace
pillow stand and pillow on page 16.*

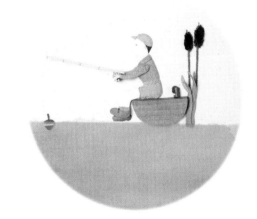

Printed in Malaysia by Times Offset (M) Sdn Bhd

# Contents

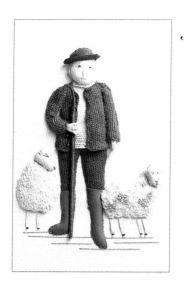

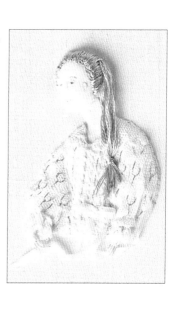

# Introduction

Stumpwork first became popular between 1650 and 1680, when it was known as raised embroidery. In the late nineteenth century it enjoyed something of a revival, and from then on became known as stumpwork.

Figures have always been an important feature of stumpwork – early raised embroideries, like the one shown below, always included at least one figure, which was often biblical, though sometimes historical.

At this time, raised embroidery was worked by the daughters of the aristocracy. The heads and hands were carved from boxwood, and covered in satin stitch after they had been applied to the background fabric. The embroiderer then added the faces and hair (often their own hair!), and decorated the finished embroidery with small beads, feathers and shells.

In this book, we show you how to make twenty-first century stumpwork figures, and how to incorporate them into an embroidery. We explain in detail how to make the various components of a figure – limbs, head, face, hair, body shape, clothes and so on – and we include detailed, step-by-step

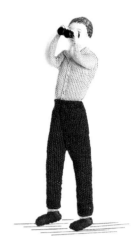

*The birdwatcher.*

*British stumpwork box, circa 1650, gifted to the Embroiderers' Guild Museum Collection, Hampton Court Palace, by Miss Hester Clough.*

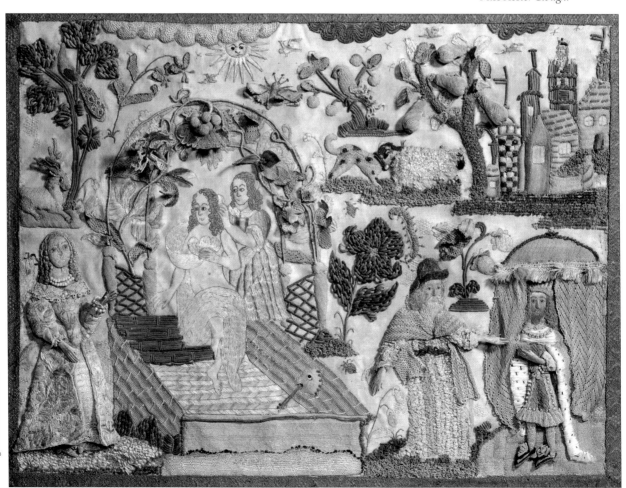

JULIA HEDGECOE

instructions for all of the needlelace and embroidery techniques you need to make clothing and to add details and embellishments to your designs.

Although we use needlelace almost exclusively for making clothes, there are times when needlelace is not appropriate. For example, we wanted to create a sense of richness in the Victorian lady's dress on the back cover which would have been difficult to achieve in needlelace. We therefore show alternative ways of making clothes using plain fabrics and machine stitching.

Three projects are included in the book, each of which shows in clearly illustrated steps how to make a different stumpwork figure. We have included full-size patterns for each of these projects, as well as for the figures that appear throughout the rest of the book.

Various materials are used to enhance stumpwork embroideries, including modelling clay, balsa wood, wires and buttons, and this is where Michael's expertise comes into play. Though not an embroiderer, Michael is responsible for designing and making the non-stitched objects that appear in many of the designs, leaving Kay free to do all of the embroidery. Michael also produced all of the drawings and diagrams in the book.

Design is an important aspect of stumpwork, often requiring the embroiderer to translate a two-dimensional drawing into a three-dimensional embroidery. This can sometimes be difficult to achieve. For example, the third project in the book is a boy fishing. The inspiration for this embroidery came from a photograph of Kay's dad fishing from a jetty that was on legs coming out of the water. However much we tried, we could not get the legs to look as though they were in the water; they always seemed to be sitting on top of it. In the end we had to abandon the idea of a jetty and instead sat the boy on the end of a boat – the effect of the water was achieved by laying a piece of blue-painted chiffon over the background fabric.

We would like to thank several people who helped us with the designs in this book – our birdwatching friends, who posed for us one day so that we could get the stance of the birdwatcher (see page 6) exactly right, Kay's football-loving cousin, Hazel, who advised us on team colours for the footballer (see page 64), and our friend Barbara who taught Kay how to make clothes with a sewing machine. The only person we cannot thank is Kay's dear dad who passed away twenty years ago, and who provided the inspiration for the fisherman (see page 60).

# Happy stitching!

# Materials

Most of the materials used in figurative stumpwork are available from good needlework shops. Specialist materials are available from mail-order outlets which advertise in needlework magazines.

## Fabrics

For figurative stumpwork we use a fine, lightweight calico as the background fabric, although silk can also be used. To support the sometimes heavily padded and wired elements used in figures, the background fabric should be backed with a good quality, medium-weight calico. This is also ideal for use as the backing fabric in needlelace pads.

For making slips (small pieces of needlework made on separate pieces of fabric), including faces, a single layer of fabric is sufficient. You can make a number of these elements in one go on a single piece of fabric.

When setting up an embroidery project, allow sufficient fabric all round the design for mounting it in a hoop and for final framing.

*A selection of the threads and materials used in figurative stumpwork.*

## Threads

A very wide range of threads is available that can be used in stumpwork – cotton, silk, metallic and synthetic threads, all in hundreds of different colours and textures – each creating a different result. With experience you will learn how to select the correct thread for the effect you want to achieve. Try to use very fine threads for the embroidery – 100/3 silks or one strand of six-stranded cotton. We often use space-dyed threads to create interesting finishes; we prefer hand-dyed threads to machine-dyed ones as the latter can give the embroidery a 'stripey' appearance.

For needlelace cordonnets we use a fine, strong crochet thread (No. 80) or fine silk in a colour that matches the filling-stitch thread.

We only use ordinary sewing thread for work that is not going to be visible in the finished embroidery: for securing pads, faces, arms and legs and for couching down the cordonnet threads in needlelace.

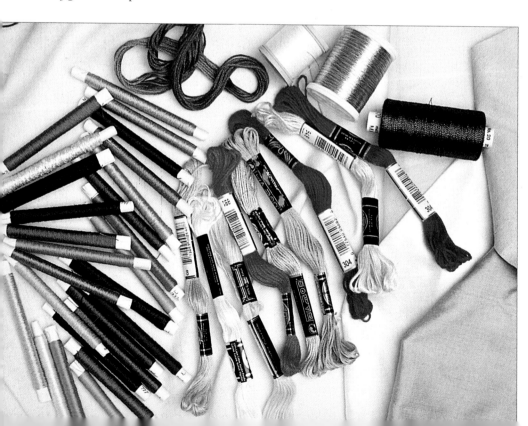

## Scissors

Always use sharp scissors. You will need a large pair for cutting fabrics, a general-purpose pair for cutting paper, wire, etc., and a small, very sharp pair for cutting threads.

## Padding materials

**Interfacing:** This is a fabric stiffener available in different grades and thicknesses. We use a firm, heavyweight grade for raising flat surfaces. It can be coloured with fabric paints.

**Felt:** This comes in different thicknesses and grades, and in many different colours. Use a smooth, thin felt in a colour that matches the embroidery thread you are using. Pads can be made using layers of felt applied over each other, or by stuffing a single layer of felt with toy stuffing.

**Toy stuffing:** Use a polyester toy stuffing, as it pulls out to almost single strands and can be pushed into the smallest of spaces. Kapok stuffing tends to be lumpy and it can be difficult to fill a space evenly. Quilters' wadding is not suitable for stumpwork.

## Embroidery frames

Mounting the background fabric in a frame is essential to maintain a good, even tension on your work. You will usually need more than one embroidery frame. Use one for your main project and another for making slips, faces, etc.

- **Circular embroidery hoops** are available in many sizes and are very easy to use. The background fabric and the support fabric are mounted between two concentric rings and secured by tightening a screwed clamp located on the outer ring.
- **Slate frames** are equally as good, especially for large embroideries, but you do have to stretch and sew the background fabric and the support fabric to the frame

Working with your embroidery hoop secured in a stand leaves both your hands free for sewing. Kay uses a Lowery workstand, on which you can adjust both the height and the distance between the hoop and the stand.

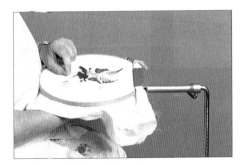

*Using an embroidery stand.*

# Needles

The needle you choose to use should be the one that is most appropriate for the purpose. It should pass through the fabric easily, and it should have an eye large enough to take the thread comfortably, but not so big that the thread keeps falling out. We use three types of needle for stumpwork:

*From top to bottom, crewel, ballpoint and sharps needles.*

- **Crewel** or **embroidery needles** for embroidery stitches. They have long eyes and sharp points.
- **Sharps needles** for all general sewing.
- **Ballpoint needles** for making needlelace and for surface stitches.

We also use **beading needles** for adding decorative beads to embroideries, and a **darning needle** for working drizzle stitch.

# Other equipment

All of the following items are useful in figurative stumpwork, and will allow you to explore its potential to the full.

**Glue**: We use PVA glue to secure toy stuffing in open-ended felt pads, to secure silk thread when wrapping wire, and to attach a calico covering to card templates when making arms and legs. We also use it to attach items made of other materials, such as balsa wood, to the background fabric. An example is the boat in the 'Gone Fishing' project.

**Thimble**: This is especially useful when sewing through leather and other stiff materials.

**Crochet hook**: A small crochet hook is useful for pulling through threads in needlelace.

**Fishing line**: We use this to strengthen the outlines of freestanding needlelace shapes.

**Wire**: Fine copper wire can be incorporated into the edge stitching of needlelace to allow it to be bent into a shape. We wrap paper-covered wire with silk thread to form hands.

**Non-woven surgical tape** or **masking tape**: This is useful for making bare arms (see page 35).

**Cocktail sticks**: We use these to help fill felt pads with toy stuffing. They can also be used to create accessories for embroidery designs, such as the fishing rod in the 'Gone Fishing' project.

**Tweezers**: These are useful when handling intricate work and for removing small trimmings of thread.

**Dressmakers' pins**: Use these to hold pads down on the background fabric before sewing them in place.

**Berry pins**: These are used to attach a needlelace pad to a needlelace pillow (see page 16).

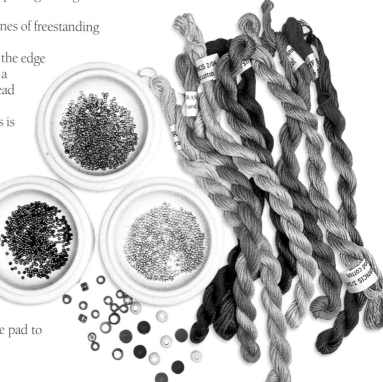

**Self-adhesive, transparent plastic**: This is ideal for use as the protective layer in needlelace pads.

**Drawing pens and pencils**: These are used for sketching your designs before you begin your embroidery, and for drawing paper patterns.

**Paper and card**: Use tracing paper to transfer designs on to plain paper. Use thin card to make templates for arms and legs. Tissue-box card is ideal.

**Lightbox**: Although not essential, a lightbox makes it easier to transfer your design on to the fabric.

**Embellishments**: Tiny beads and buttons can be used to decorate your embroideries.

**Gold gel pen**: We use a gold gel pen to outline shapes on background fabrics before applying pads or stitches.

**Fabric paint and brushes**: Fabric paint is used to colour interfacing pads, cotton moulds and fabric slips before embroidering over them, to add eyebrows and nostrils to faces, and to paint the backgrounds for landscape designs. They can also be used for painting arms and legs to give them a more realistic skin tone.

**Acrylic paints**: These are used to paint items made from balsa wood.

**Silk frame and silk pins**: If you need a painted background on your fabric, secure it in a silk frame with silk pins before applying the paint.

*All of the additional equipment mentioned on pages 10–11 that you will need for stumpwork.*

# Getting started

## Transferring the design

When you have decided upon a suitable design for your stumpwork, the first thing you need to do is transfer the outline of the design on to the fabric to show you where to place the various elements of your embroidery in relation to each other.

There are many ways of getting the design outline on to the fabric; our preferred way is with a gold gel pen. Draw only the outline of the design on to the background fabric; there is no need to include any of the detail as this will be covered by the embroidery. Your outline should be slightly smaller than the finished picture to ensure that it is hidden beneath the embroidery. If you have elements in your embroidery that are going to stand free of the background fabric, do not draw in any lines that will show.

1. Find the centre of the fabric by folding it in four and mark it with a pin.

2. Place the piece of paper on which you have drawn your design on a lightbox, or alternatively work by a sunny window. Centre the fabric over the design.

3. Draw around the outline of the design using a gold gel pen.

# Binding an embroidery hoop

To avoid the fabric slipping in the embroidery hoop, the inner ring can be bound with strips of cotton cut on the bias (across the grain). Wrap the cotton tightly and evenly, making sure you leave no gaps in the binding.

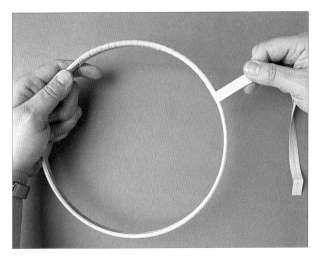

*Binding the inner ring with strips of cotton fabric.*

# Mounting the background fabric

When you have completed the outline, bound the inner ring of the hoop and, if necessary, added a painted background, you are ready to mount the fabric. If possible use a hoop that is 50mm (2in) larger all round than the design. If you do not have a hoop big enough, consider using a quilting hoop or slate frame. If you have to use a smaller frame which will not go over the whole design, remove the fabric from the ring each time you finish stitching. If the fabric is left in the ring for any length of time, the ring will mark the fabric.

If you use a piece of silk or fine calico as your background fabric, it is advisable to place a piece of medium-weight calico behind the embroidery. Stumpwork can be heavy, and silk and fine calico on their own may not support the embroidery. Tighten the clamp sufficiently to hold both layers of fabric in place, pulling both of them taut as you do so.

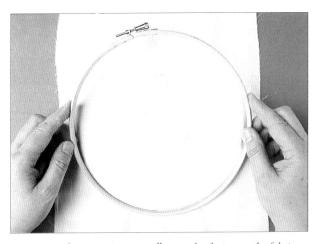

*Positioning the outer ring centrally over the design on the fabric.*

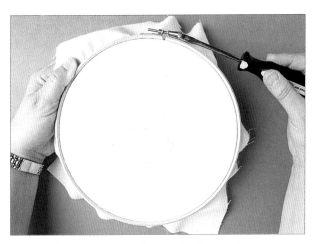

*Securing the outer ring by tightening the clamp with a screwdriver.*

13

# Needlelace techniques

Most needlelace shapes have simple outlines, where the cordonnet threads (these are the two threads that are couched round the edge of the shape to support the filling stitches) are joined on one side of the shape. However, some shapes, such as the fisherman's shirt (see pages 52–53) with a branch for the collar (see step 3 opposite), need careful planning to ensure they are able to support the finished needlelace. On these pages, we show you how to make a needlelace pad, plan the cordonnet for the shirt and work a basic filling stitch.

When making any piece of needlelace to fit over a body part it is imperative that you check the sizes of the patterns before you start working. The sizes of the patterns we have provided in this book are for the parts we made, and yours may be different in size or tension.

## You will need

Medium-weight calico
Paper pattern
Self-adhesive transparent plastic
No. 7 sharps needle
No. 10 ballpoint needle
Crochet thread No. 80
Sewing thread
100/3 silk thread
A large-eyed needle or a very small crochet hook
Berry pins
Scissors

## Needlelace pad

You can make small needlelace pads to suit individual shapes or make them large enough to accommodate several pieces. If you use the latter method, it is best to complete all the shapes on the pad before releasing any of them.

Make a sandwich starting with two or three layers of medium-weight calico, followed by the paper pattern, and finally a top protective layer of self-adhesive transparent plastic with the backing removed. Tack all the pieces together firmly.

*The needlelace pad.*

## Making a cordonnet

It is essential that cordonnets stay intact when the needlelace is released from the backing fabric, so joins must be kept to a minimum. Take time to plan the layout properly so that you can build a cordonnet from a continuous length of thread. Use the full-size pattern below to estimate the length of thread required. Lay the thread along all the lines on the diagram including the bottom line of the collar, double this length and add a small extra allowance. You will need 380mm (15in) of crochet thread No. 80 for this shirt.

The following steps show you how to build this particular shape, with its intersections at each end of the bottom line of the collar. A more complicated shape, with lots of intersecting veins, is shown on page 44, but to achieve it you simply have to apply these same basic rules.

*The completed cordonnet.*

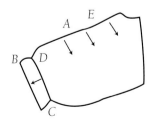

*Full-size pattern for the shirt shape.*

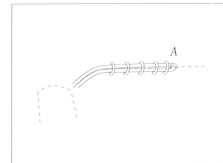

*Make the couching stitches small, firm and neat. A poor foundation will result in a disappointing piece of lace. If the couching thread runs out before you have finished the cordonnet, take the thread to the back of the needlelace pad and secure it with three or four stitches, then start a new length.*

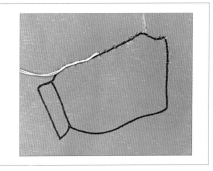

1.  Fold the cordonnet thread roughly in half, making one thread 75mm (3in) longer than the other. Lay the loop end of this thread over point A, then start to couch the cordonnet to the needlelace pad. Using a No. 7 sharps needle with a single length of sewing thread, bring the sewing thread up from the back of the pad and through the loop of the cordonnet thread. Take it over the thread and back down through the same hole. Bring the thread up on the pattern line, 3mm (⅛in) away from point A, make a stitch over both cordonnet threads, then take the sewing thread back through the same hole. Continue round the outline.

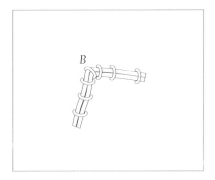

2.  When you reach point B, make an extra couching stitch at the point of the collar (a sharp point is useful when making the filling stitches). Continue couching round the top edge of the collar back towards point C.

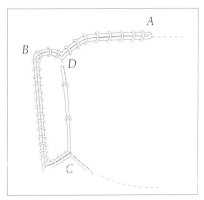

3.  When you get to point C, separate the cordonnet threads. Take the long one towards point D, couching it down in two or three places to hold it in position.

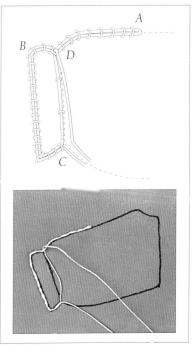

4.  At point D, take the thread under and over the couched outline threads, lay it back down against the single thread, then couch down both threads to C.

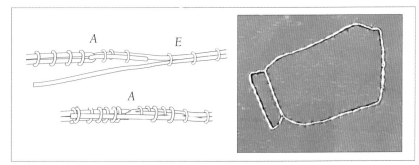

5.  Continue couching round the shape to point E. At point E, take one thread and pull it through the original loop at A using a small crochet hook or large-eyed needle. Lay it back to E and couch over the three threads. Take the other thread and couch it down alongside the existing threads from A to D for a short way. Fasten off the couching thread on the back of the pad, then trim away any excess cordonnet threads.

# Filling stitches

Two basic filling stitches are used in this book – single Brussels stitch and corded single Brussels stitch. The shirt design in the 'Gone Fishing' project is filled with corded single Brussels stitch. The body section is worked from the back to the front of the shirt, as indicated by the arrows on the drawing. The filling stitches do not pass through the sandwiched layers of the needlelace pad, but are worked over and supported on the cordonnet threads.

Joins in the filling thread can only be made at the end of each row, so you must ensure that you always have sufficient thread to work a full row of stitches. A good guide is to have at least three to four times the length of the space being worked.

For the filling stitches use a No. 10 ballpoint needle and 100/3 silk thread. To help maintain an even tension, and therefore keep your stitches neat, it is advisable to work on a needlelace pillow. Pin your needlelace pad securely on the pillow with berry pins.

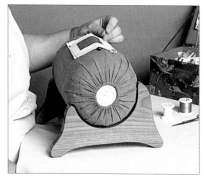

*Working on a needlelace pillow.*

## Single Brussels stitch

*Start this stitch with a row of buttonhole stitches across the cordonnet. The spacing of this foundation row of stitches governs the texture of the finished piece: use loose stitches for an open texture; tight ones for a dense texture. Subsequent rows of stitches are looped into those above.*

## Corded single Brussels stitch

*This stitch is worked in much the same way as single Brussels stitch except that, at the end of each row of buttonhole stitches, the thread is laid back across the work as a 'cord'. The next row of stitches is then worked round this cord and the loops in the previous row.*

*Single Brussels stitch.*

*Corded single Brussels stitch.*

*Both of these examples have the same number of stitches in the row, but notice how the corded version has a denser structure.*

*This enlarged view of the first row of buttonhole stitches shows how the loops are formed as you progress.*

1. Secure the end of the filling stitch thread to the cordonnet by passing it under a few of the couching stitches. Take it through to a point just short of the intersection between the base of the collar and the outline of the shirt.

2. Work a row of evenly spaced buttonhole stitches across the back of the cordonnet. Do not pull the stitches too tight as you must work through their loops for the next row.

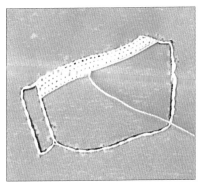

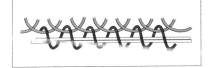

5. Secure the last row of stitches by whipping each loop to the cordonnet.

3. When you reach the end of the row, take the needle and thread under both cordonnet threads, then whip it over **both** threads and lay it back across the row as a cord. At the other end, whip the thread round and down the cordonnet to where you want the next row of stitches to start.

4. Work back across the shape, working one buttonhole stitch round the cord and in each loop of the previous row. Whip the thread round the cordonnet again then lay the cord across the shape. Continue until the area is filled. Always take your needle and thread straight out under the cordonnet threads; this will help to keep the rows straight.

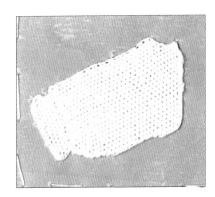

6. Once the body of the shirt is completed it is time to work the collar. Work across the collar with a row of buttonhole stitches, from the fold of the collar to the outer edge.

# Top stitching and releasing the needlelace

One characteristic of needlelace is a raised outer edge, although in figurative stumpwork not all edges need top stitching. Only those edges that are freestanding, such as the hem of a skirt or the edge of a shirt collar, are top stitched. Other edges are stab stitched to the background fabric, usually over some form of padding. Extra threads, fishing line or wire may be added under the buttonhole top stitching. By adding fishing line the edge will be stiffened; by adding wire the edge can be sculptured. Work the buttonhole stitches as close together as possible with the loops lying towards the outer edge of the shape. When the top stitching is complete, release the needlelace from the backing fabric and assemble it on the embroidery.

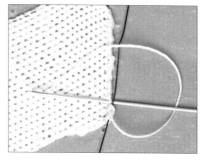

*To stiffen or sculpt an edge, lay either fishing line or wire along the edge and top stitch it in place.*

1. For the shirt, only the top and sides of the collar are top stitched. Using the silk thread, work tight buttonhole stitches all round the outside edge of the collar shape.

2. Remove the tacking stitches around the design, fold back the bottom layer of calico, then use fine-pointed scissors to snip through all the couching stitches.

3. Remove the needlelace, then use a pair of tweezers to remove any remaining fragments of the couching threads from the back of the lace.

*The completed shirt, enlarged for clarity.*

# Other ways of making clothes

For people who prefer machine to hand stitching, machine-made clothes offer a good alternative to needlelace. Begin by placing a piece of dissolvable fabric into an embroidery hoop and pulling it taut. Pin the paper pattern of the clothes you are making on to the dissolvable fabric, remembering that you will be working with the hoop upside-down so that the fabric lies flat on the bed of the sewing machine. Thread the machine with your chosen thread and outline the shape with straight stitches. Remove the pattern, then fill the shape by sewing lines of stitches backwards and forwards within the outline. Work first in the vertical plane and then in the horizontal. The filling stitches must be worked over the outline stitches otherwise the shape will fall apart when the fabric is dissolved. The more stitches you sew the denser will be the finished texture.

When you are satisfied with the stitching, remove the fabric from the embroidery hoop and hold it under running cold water to dissolve the fabric. (It is advisable to put the plug in the sink, otherwise if you drop the piece of machine embroidery it could go down the plug hole!)

In the step-by-step pictures below, we show how to make the fisherman's shirt using machine stitching.

*Fabric clothes may sometimes be more appropriate than needlelace, for example this colourful clown's outfit was made using scraps of material with different patterns on. The fabric you choose should be of the right weight and texture, be easy to sew and manipulate, and any design on it must be in proportion to the picture. To soften a piece of fabric to make it more manageable, try washing it first.*

1. Pin the paper pattern to the dissolvable fabric.

2. Machine stitch around the outside of the pattern.

3. When the outline is complete, remove the paper pattern.

4. Fill in the outline using rows of straight stitch, first working vertically and then horizontally.

# Embroidery techniques

In this section we explain how to do all of the embroidery stitches used in the projects. We use a No. 9 embroidery needle, and either one strand of six-stranded cotton or 100/3 embroidery silk, though in the demonstrations below we often use three strands of six-stranded cotton to make the embroidery clearer.

## Stab stitch

Use stab stitch to secure pads, padding, faces, arms, legs and other elements of your design to the fabric.

Bring the needle up through the fabric, as close as possible to the shape, then take it back down through the shape, again as close as possible to the edge of the shape. It is a good idea to begin by securing the shape with four holding stitches, at the top, bottom and both sides, and then repeat the stitch at regularly spaced intervals around the shape.

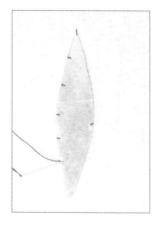 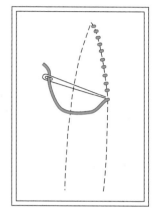

## Satin stitch

Satin stitch can be worked over a stiff padding such as interfacing or directly on to the background fabric. Interfacing provides a firm base and a well-defined shape for your embroidery. We usually paint the interfacing to match the thread colour to minimise the amount of white showing through. It accepts fabric paint quite easily, but let it dry overnight.

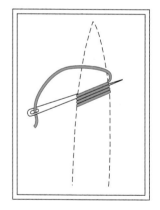

1. To make this leaf shape, bring the needle up through the fabric one-third of the way down one side of the shape. Take the thread diagonally across the shape, hold it flat and take it down through the fabric against the interfacing.

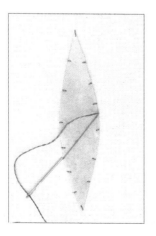 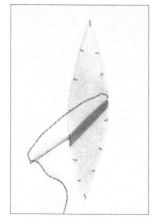

2. Bring the needle up on the right-hand side of the shape next to the first thread, then take it across the leaf parallel to the first stitch. Continue working like this until you reach the bottom of the shape, then work another series of stitches to cover the top part.

# Detached chain stitch

We use a single chain stitch to embroider the eyes and mouths on faces. In the following pictures, we have used three strands of cotton for clarity; in your embroidery we recommend you use a single strand of six-stranded cotton.

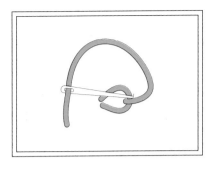

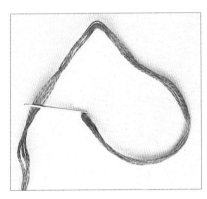

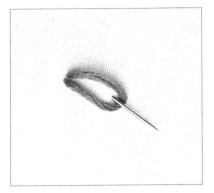

1. Bring the needle up through the fabric, then take it back down beside the point at which it came up.

2. Pull the thread into a loop, then bring the needle up through the fabric at the top of the loop to secure it. The point at which you bring the needle up will determine the size and orientation of the stitch.

3. Take the needle back down through the fabric on the other side of the loop to make a small stitch the same width as the thread.

# Drizzle stitch

We used this stitch to make the worm in the 'Gone Fishing' project, and the snail shell in the fairy picture on page 3.

We have used three strands of six-stranded cotton in the demonstration on the following page; in your embroidery, you should use a single strand. Drizzle stitch should always be done using a darning needle – it is the same width all along its length, ensuring that all the knots are the same size.

*1. Come up from the back of your work, unthread the needle, then re-insert the needle halfway into the fabric approximately 2mm (1/8in) from the cotton.*

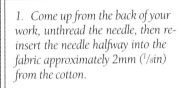

*2. Twist the thread to form a loop, and pass the loop over the top of the needle to form a cast-on stitch.*

*3. Pull the thread taut, but not too tight.*

*4. Cast on the required number of stitches.*

*5. When you have the required number of loops, re-thread the needle.*

*6. Pull the needle through the cast-on stitches to complete the drizzle stitch.*

# *Drizzle stitch (continued)*

1. Bring the thread up through the fabric. Unthread the needle, then push it halfway back into the fabric approximately 2mm ($^1/_8$in) from the point at which it came through.

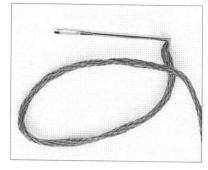

2. Make a loop in the thread.

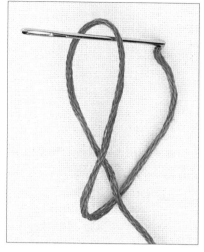

3. Pass the loop over the needle to form a cast-on stitch.

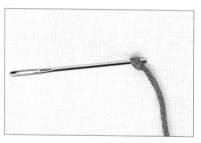

4. Tighten the cast-on stitch around the lower part of the needle, as close to the fabric as possible, but not *too* tight.

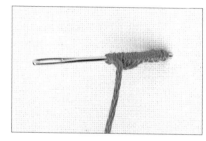

5. Repeat steps 2 to 4 as many times as you need to create a series of cast-on stitches along the shaft of the needle. To make the worm in 'Gone Fishing' we used twenty knots.

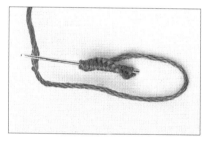

6. Re-thread the needle and pull the needle and thread through the stitches to complete the drizzle stitch. Fasten the thread securely at the back of the fabric.

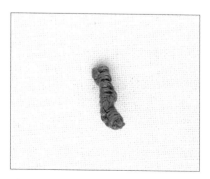

*The completed drizzle stitch.*

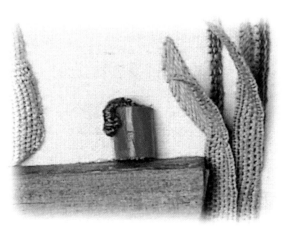

*The worm peeping out of the fisherman's tin was made using drizzle stitch (see page 58).*

# Raised stem band stitch

This is a useful stitch for creating solid blocks of embroidery, for example on tree trunks, branches and thick plant stems. We used it to make the bulrush stems in the 'Gone Fishing' project.

We have used two strands of six-stranded cotton in two different colours to demonstrate clearly how to do this stitch, but in your embroidery you should use a single strand of cotton and one colour only.

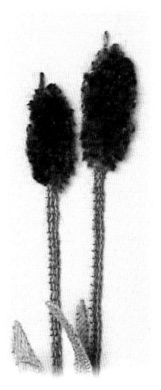

Raised stem band stitch was used to make the bulrush stems in the 'Gone Fishing' project (see page 53).

1. *Using one strand of six-stranded cotton, sew a series of straight stitches equally spaced from top to bottom across the shape.*

2. *Starting at the bottom, work stem stitches over the straight bars. When you reach the top, take the needle through the fabric, bring it back up at the bottom and start again.*

3. *Continue working stem stitch up the shape until the area is covered.*

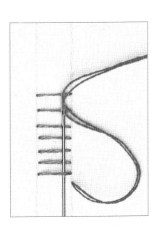

1. Sew a series of straight stitches across the shape. Start the stem stitch at the bottom of the shape.

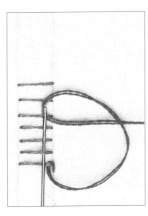

2. Work the stem stitch into the second bar.

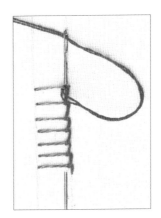

3. Finish the first row of stem stitch by taking the needle through the fabric and bringing it back up at the bottom.

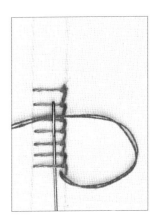

4. Begin the second row of stem stitch and repeat steps 3 and 4.

# Turkey knot stitch

Turkey knot stitch is very useful in stumpwork; for example you can vary the lengths of the loops to make different hair styles (see page 31). We usually use three strands of six-stranded cotton. The bulrush heads in the 'Gone Fishing' project were made using this stitch – they are easier to work if you turn them on their sides and work from right to left.

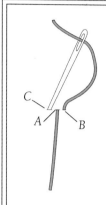

1. Insert the needle through the fabric at A, leaving a tail of thread on the surface. Bring the needle up at B, then down at C; pull the thread tight to make a small securing stitch.

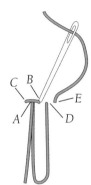

2. Bring the needle back up at A, then insert it at D, leaving a loop of thread on the surface. Bring the needle up at E, then down at B; again, pull the thread tight to make a securing stitch.

3. This stitch produces rows of secured loops which can then be trimmed to any length you want.

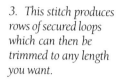

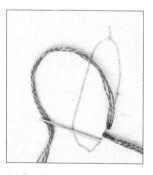

1. Starting near the bottom of the shape, make the first knot leaving a short tail of thread on the surface.

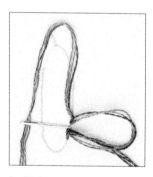

2. Tighten the knot, then, leaving a short loop on the surface, make another knot just above it.

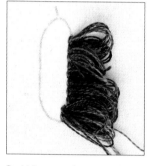

3. When you have completed the first row of knots, take the thread across the back of the fabric and bring it up just to the left of the first row of knots, then make another row of knots.

4. Continue working across the shape until it is completely covered.

5. When the shape is completely filled in, trim off the loops to the required length. To make a fluffy pile, trim them close to the securing stitches, and 'fluff them up' using an eyelash brush.

# Bullion knot

Bullion knots are long, wrapped stitches that can be curled into shapes. This stitch is also called worm stitch and caterpillar stitch, which suggest two ways of using it. We also use it to make ears (see page 32) and flower petals. Bullion knots can be made using any number of strands of thread, depending on the size of stitch you wish to create, but it is important that the thread is smooth.

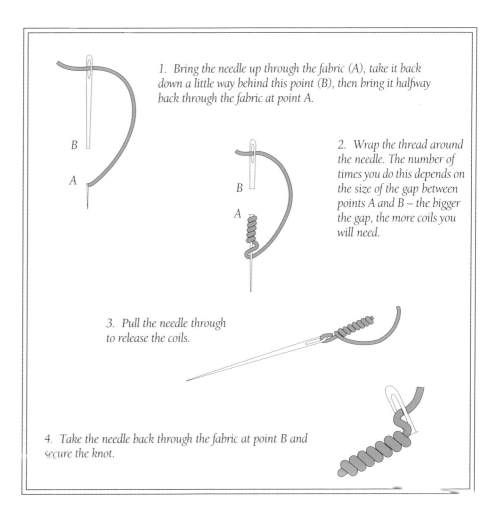

1. Bring the needle up through the fabric (A), take it back down a little way behind this point (B), then bring it halfway back through the fabric at point A.

2. Wrap the thread around the needle. The number of times you do this depends on the size of the gap between points A and B – the bigger the gap, the more coils you will need.

3. Pull the needle through to release the coils.

4. Take the needle back through the fabric at point B and secure the knot.

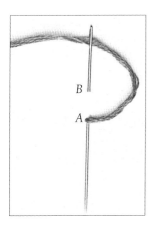

1. Create the first stitch. The length of the gap you leave between A and B determines the final length of the bullion knot.

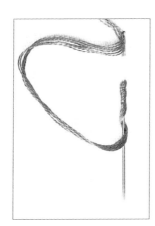

2. Wrap the thread around the needle. The longer the gap between A and B, the more coils you will need.

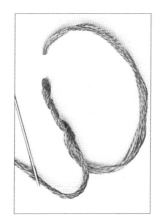

3. Release the coils from the needle by pulling the needle through.

*The finished bullion knot.*

# French knot

A French knot is an extremely versatile stitch. A single, tight French knot made using a single thread twisted once around the needle can be used, for example, to decorate a butterfly's wing or a ladybird. By loosening the tension and using two strands twisted twice around the needle, bolder knots can be made. These can be used as filling stitches to create textured areas such as foliage, curly hair and sheep's fleece.

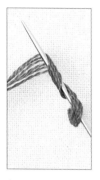

1. Wind the thread around the needle.

2. Tighten the knot.

The completed French knot.

1. Bring the thread up through the fabric, hold the thread taut, then twist the needle round the thread twice.

2. Tighten the knot and take the needle back down through the same hole.

3. The finished French knot.

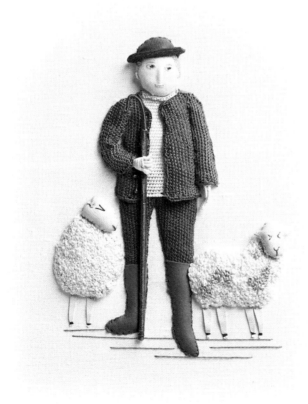

Densely worked French knots were used to create the sheep's fleece in this embroidery.

# Making arms and legs

Arms and legs are usually made of thin card covered in fine calico (tissue-box card is ideal). Once the shape is made it can be painted with a fabric paint to obtain any skin tone you want. Here we show you how to make an arm. The same technique is used to make a leg; it is only the shape that differs. If both arms or both legs are visible in your design, you would normally sew one to the background fabric and the other in front of it, freestanding, for a three-dimensional effect.

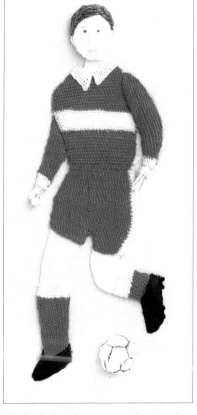

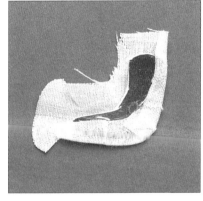

1. Cut a piece of thin card from a traced pattern. Use this as the template.

2. Place the template on a piece of fine calico, and cut round it. Make the shape at least 5mm (¼in) wider all round than the card template. Snip around the outside of the calico, from the edge of the calico inwards to the edge of the card.

*The footballer's legs were made using the technique shown here. For his hands we used the method described on pages 34–35. The wires were extended to make the arms and wrapped in masking tape for a three-dimensional effect.*

3. Glue the calico to the back of the arm with PVA glue. The arm is now complete and ready for painting or for sewing to the background fabric.

---

*Tip*
Make sure the calico is glued to the back of the card only, and not to the front.

---

# Making heads and faces

Heads and faces are fascinating subjects in their own right. In the early days of stumpwork they were made of wood, usually boxwood, and were carved by a carver and supplied to the embroiderer as part of a kit to complete the project.

Today heads are usually made separately from a piece of stuffed calico (a 'slip'), applied to another piece of calico mounted in a ring and then decorated. The following sequence of pictures shows the way we make faces that are facing forwards. Side-facing ones are treated differently (see page 32). For clarity we have used blue thread, but normally you would use a colour that matches the fabric.

1. Trace the face outline shape, on the cross of the fabric, on to a piece of fine calico. Make the outline 6mm (¼in) larger than the finished face size you want.

2. Put a strong knot on the end of a length of sewing thread and make a running stitch around the shape. Leave the end of the thread loose.

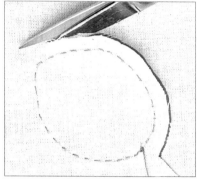

3. Cut around the edge of the shape using a small pair of sharp scissors, approximately 6mm (¼in) outside the gold outline.

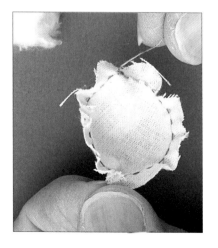

4. Start to pull the loose end of the running stitch to create a pouch the size of the face you want.

5. Fill the pouch with toy stuffing. Use a cocktail stick to help push the stuffing in. Pull the pouch tight to the size you want, making sure you keep a pleasing shape to the head, and secure the ends of the running stitch at the back.

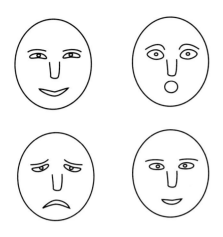

*These drawings show just some of the facial expressions that can be achieved on stumpwork figures.*

6. Turn the pouch over and position it on another piece of fine calico in an embroidery ring. Starting at A, attach the head shape to the fabric using small, neat, closely worked stab stitches. When you reach point B, go back to A and repeat to C. Return to point B and stitch to D, then go back to C and stitch to E. This pattern of working will help ensure your head remains symmetrical.

7. Push more toy stuffing through the opening at the top until the head is nice and firm. Complete the stitching around the top of the head.

8. To make the nose, thread a needle with sewing thread and put a knot in the end. Pinch the fabric where the nose is to be and pass the needle and thread through the head three or four times. The amount you pull the thread will determine the nose shape.

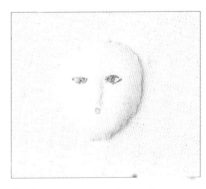

9. The eyes are made by sewing a detached chain stitch with one strand of cotton in a colour of your choice. Single French knots are used for the coloured parts of the eye. Position the French knots carefully as they help define the expression on the face.

10. The eyebrows and the nostrils are painted on using fabric paint. The mouth is a chain stitch using one strand of cotton. Shape the mouth according to the expression you want on the face.

Once the felt padding for the hair has been sewn in position (see the next page), the face can be cut out and applied to the background fabric.

*Tip*
The head is usually the last element to be sewn in place, and once attached it is very difficult to remove. This is why we prefer to make complete heads as slips, and attach them to the embroidery only when we are totally satisfied with the end result.

# Hair styles

Hair styling is a matter of personal choice and ought to be appropriate for the character you are creating. We have shown below just four different methods of hair styling, but they can all be adapted to make the style you choose for your figure. Most styles require you to apply some padding under the stitches to raise the hair away from the face. We usually use a single layer of felt, in a colour that matches the hair colour, sewn in place using stab stitch. Each style is shown half completed, so that you can see the felt padding, and completed to show the final result.

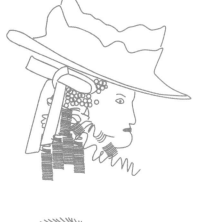

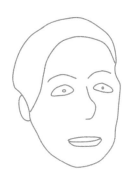

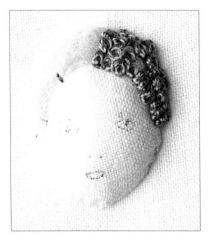

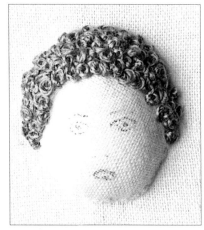

*Curly hair is easy to do. Just keep on adding French knots until the felt padding is completely covered.*

### Tip
If your figure has long hair, it may need to be sewn on to the background fabric first so that it hangs down behind the figure's clothes.

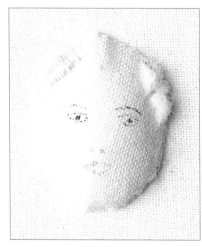

*A balding man is probably the most fiddly to do as the amount of hair is very small. Use white felt and satin stitch over the top*

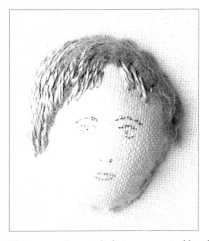

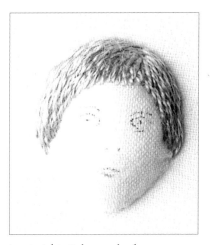

*This woman's straight hair was created by placing straight stitches randomly over the felt padding. It is important to get the direction of the stitches right to give the correct look.*

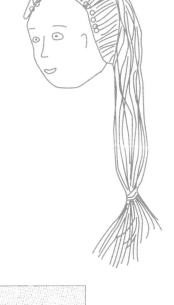

*This girl does not need felt padding as there are a lot of stitches to pad the hair out. Use three strands of thread and work a row of long turkey knot stitches around the top of the scalp. Cut the ends of the loops and arrange the hair in whatever style you choose. Trim off any excess hair, and sew on some satin stitches for the fringe.*

# Side-facing heads

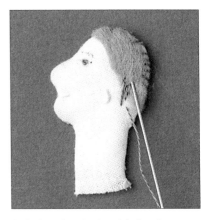

1. Trace the pattern for the head on to a piece of tracing paper. Make sure the neck is long enough to sit behind the body. Cut around the outline of the pattern. Use this as a template to cut out a piece of thin card.

2. Use the card template to cut a piece of fine calico, 6mm (¼in) larger all round than the card shape. Place the card shape in the middle of the calico and snip the calico from its edge to the card all round the head. Apply PVA glue to the back of the card and fold over the edges of the calico carefully to maintain the shape of the head. Do not glue the base of the neck.

3. When the glue has dried push some toy stuffing between the card and the calico via the base of the neck to give the head a rounded appearance. The eye and mouth are made the same way as on the forward-facing head. Apply a piece of felt for the hair padding using stab stitch, and stitch on the hair design (see pages 30–31).

*Tip*
The ear is a bullion knot but made slightly differently from a normal bullion knot. Make the windings longer than usual so that they curl round when the needle is withdrawn.

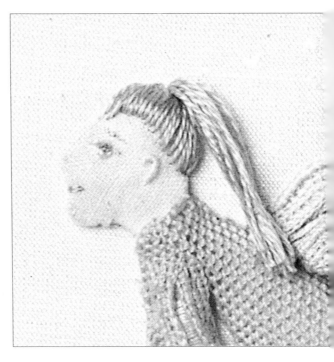

*Detail from an embroidery of a fairy kneeling on a toadstool. Notice how her features have been shaped to give her an elfin appearance.*

# Making different body shapes

To give your stumpwork figures a three-dimensional appearance, add various layers of felt padding underneath their clothes. By varying the size, shape and number of layers, different body shapes can be achieved. Most figures need a single layer of padding sewn over their whole body, with one or two extra layers sewn underneath where required. For example, a woman may need an additional layer of padding around her bust. The toddler in the 'Child Paddling' project was given an extra layer of padding around his bottom for extra chubbiness, whereas Uncle Joe, shown here, was made plumper by adding two extra layers of felt padding around his middle (see the pictures below). Alternatively, a little toy stuffing can be used for additional padding.

When building up layers of padding, remember that the top layers need to completely cover the bottom layers, so you will need to make them progressively larger (by approximately 2mm, or ⅛in, all round). The first layer needs only a few stab stitches to hold it in place. Subsequent layers require more stitches, with the final layer being secured with small, neat, closely worked stitches to create a smooth edge. For each layer always apply four securing stitches first to hold the shape in place – one at the top, one at the bottom and one at each side – before filling in with the rest of the stitches. To join two pieces of felt padding together, use herringbone stitch. This is shown in step 3 below.

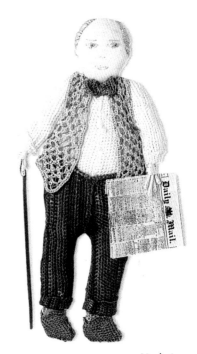

*Uncle Joe.*

1. Attach the first layer of felt padding around the middle part of the figure. Secure the pad first with four stab stitches then add another four stitches placed between the first ones. This first felt layer should lie well within the gold outline.

2. Position the second layer of felt over the first one, and secure it with more stab stitches than the first layer.

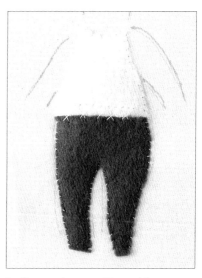

3. Sew on the rest of the padding, covering the upper part of Uncle Joe's body and his legs.

# Making hands

We like to make hands that look as realistic as possible. Individual fingers and thumbs are made by wrapping short lengths of paper-covered wire, then these are wrapped together to form palms and wrists. The fingers on the finished hand can then be bent into realistic shapes.

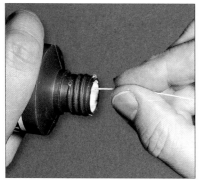

1. Cut the paper-covered wire into five 50mm (2in) lengths (one length for each finger), then dip the end of one finger in PVA glue.

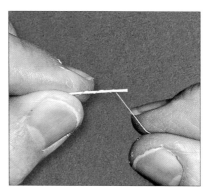

2. Starting approximately 20mm (¾in) from the end, loosely wrap a white thread down to the end of the wire.

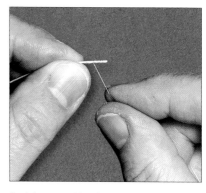

3. Now work back along the wire, closely wrapping the thread for approximately 12mm (½in). Add a little more PVA glue if necessary to secure the thread to the wire. Leave a longish tail of thread on each finger.

4. Repeat steps 1–3 for each finger and thumb.

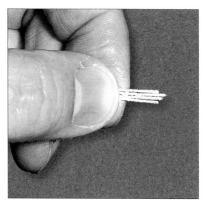

5. Take four fingers, and space them to mimic the length of those on a real hand.

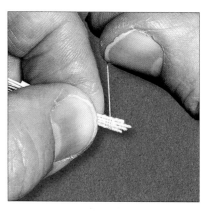

6. Using one of the tails of thread, wrap the four fingers together for three or four turns to start to form the palm.

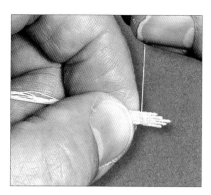

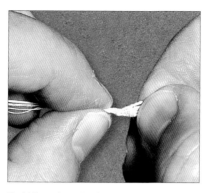

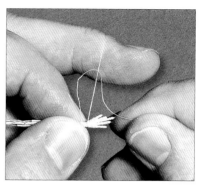

7. Place the wrapped-wire thumb beside the fingers, then continue wrapping thread down the palm.

8. When the palm is complete, hold the fingers and thumb flat between two of your fingers, then squeeze the unwrapped wires together to form a wrist.

9. Now wrap the wrist and continue along the forearm for approximately 6mm (¼in). Fasten off the wrapping with one or two half-hitch knots.

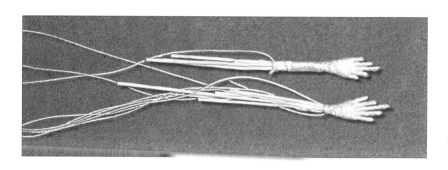

*A pair of hands ready to incorporate into an embroidery.*

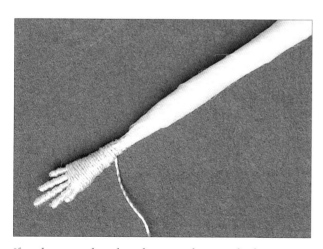

*If you have to make a three-dimensional arm, make the wires longer and follow the technique above. Once you have a finished hand, wrap strips of non-woven surgical tape or masking tape around the wires above the wrist. Make the arm more bulky at the top than at the bottom, and make a man's arm thicker than a woman's.*

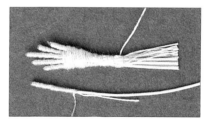

*A woman's or child's hand and finger. These were made using a single strand of wire.*

*A man's hand and finger. To make a man's finger, start wrapping the wire in the normal way, finishing approximately 5mm (¼in) from the end. Carefully bend the end of the wire back on itself and continue wrapping over both wires. Make up the hand in the normal way.*

35

# Child Paddling

The appeal of this little boy paddling could not be ignored, and we just had to reproduce him in stumpwork.

This is a simple project, ideal for those new to creating figures in stumpwork, as there are no hands or face to construct. The feet are hidden by the foaming water.

The clothes are all made in needlelace and the foaming water is created using machine embroidery, although it can also be made using French knots (see page 37).

## You will need

Embroidery hoop, 200mm (8in)
Silk frame and silk pins
Needlelace pad(s)
Lightweight calico, 250mm (10in)
square
Medium-weight calico, 250mm
(10in) square
Silk organza, 150mm
(6in) square
Water-soluble fabric
Stranded cotton or 100/3
embroidery silk
Sewing thread
No. 9 embroidery needle
No. 10 ballpoint needle
Dressmakers' pins
Scissors
Blue fabric paint and
large paintbrush
Tracing paper
Pencil
Gold gel pen
PVA glue
Thin card
White felt for padding
Toy stuffing

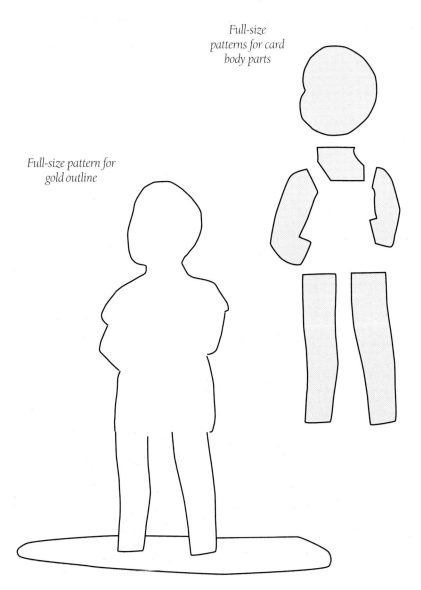

*Full-size patterns for card body parts*

*Full-size pattern for gold outline*

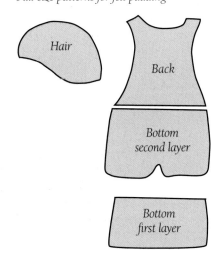

*Full-size patterns for felt padding*

Hair

Back

Bottom
second layer

Bottom
first layer

36

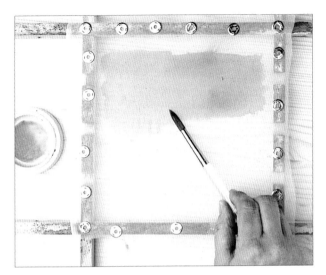

1. Attach the silk organza to the silk frame. Make sure it is taut. Paint on an area of blue using fabric paint and a large paintbrush. Allow the paint to dry, then remove the fabric from the frame.

3. Create the effect of foaming water by machine-stitching with a white thread on to water-soluble fabric (see page 19). Trace the outline of the foam from the pattern on page 36, leaving two spaces where the boy's legs will be, on to the water-soluble fabric. When you have filled the shape with machine stitching, Dissolve the fabric by rinsing it under cold running water, and attach the machine-stitched slip to the central area of the blue-painted organza using stab stitching.

4. Remove the calico from the hoop and trace on the pattern using gold gel pen. Replace the calico in the hoop, this time with a backing of medium-weight calico. Make sure the fabric is taut, and that the picture is positioned centrally in the ring.

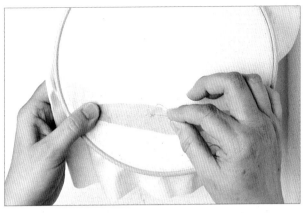

2. Cut out a piece of the blue-painted organza to make the water. Secure the lightweight calico in the embroidery hoop. Choose a suitable position for the water, and attach the organza to the calico using stab stitch in a matching coloured thread.

*Tip*

If you do not have a sewing machine, you can make the white foam using French knots (see page 26) embroidered straight on to the organza.

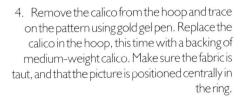

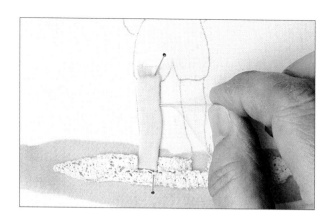

5. Make the limbs and neck using the patterns on page 36. Follow the technique described on page 27. Taking each part in turn, first pin them to the background fabric then sew them in place using stab stitches.

*Tip*
Always make sure the legs are sufficiently long for the tops of them to be hidden under the figure's skirt or shorts.

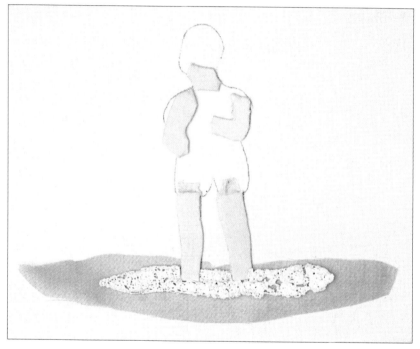

*The figure, with all the body pieces (apart from the head) in place.*

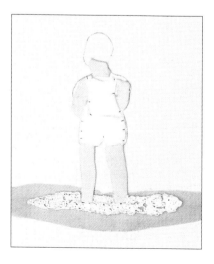

6. Using the templates on page 36, cut out the shapes for the felt padding. To give the bottom a more rounded appearance, two layers of felt are used. Attach the first layer of padding to the boy's bottom using stab stitch.

7. Attach the second layer of felt to the boy's bottom, and the single layer to his back. Use stab stitch, as before.

38

# Needlelace

Make sure the patterns fit the child in your embroidery before making the needlelace, and adapt them if necessary.

Make all the needlelace using corded single Brussels stitch in colours of your choice using the patterns shown opposite. Take note of the direction of working.

Use top stitching along the bottom of the sleeves, the neckline of the boy's top, and the neckline and bottom of his dungarees.

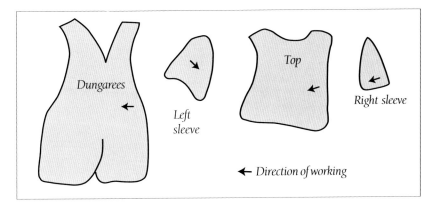

Dungarees

Left sleeve

Top

Right sleeve

← *Direction of working*

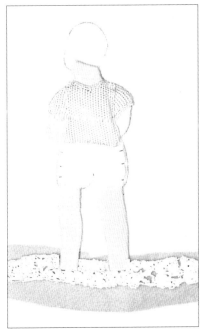

8. Sew the sleeves over the calico-covered card arms first, followed by the back of the boy's top. Use the same thread as you used to make the needlelace.

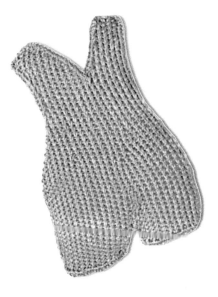

*Tip*

When you are making a piece of needlelace, leave long threads and use these to sew the lace to your embroidery.

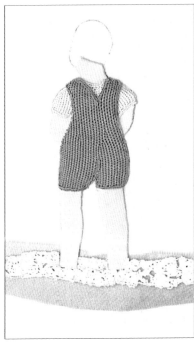

9. Attach the dungarees to the figure.

10. Make the head, using the template on page 36 and following the method shown on pages 28–29, and attach it to your embroidery, Finally, add short blond hair using long satin stitches (see page 20).

39

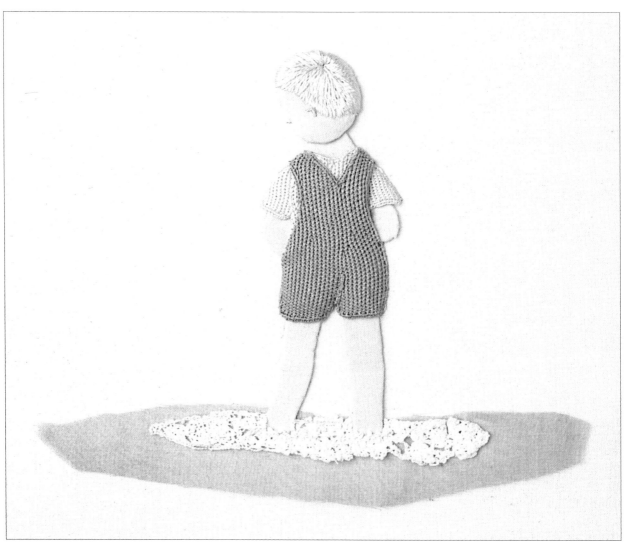

*The completed project.*

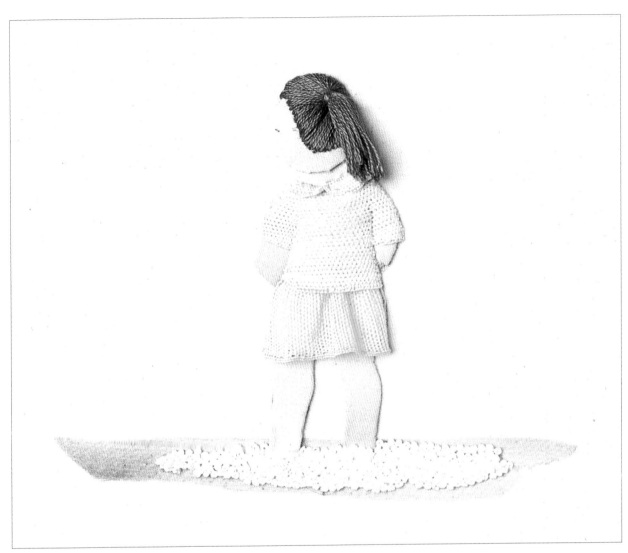

To complement the little boy, we have used the same techniques to make a little girl paddling. Notice how the slightly chubbier legs make her look younger. The foaming water in this picture was made using French knots, and the girl's hair was made using long turkey knot stitches (see page 31). The skirt was made slightly fuller than the pattern so that it lay in natural folds when it was sewn to the background fabric. To add a petticoat, attach some lace to a separate piece of cloth and sew it on to your embroidery before attaching the skirt.

# The Fairy

This enchanting figure is challenging but not impossible, even for a beginner. The same rules for making needlelace apply to the shapes in this project as they do to any other. They do, however, need a little more patience and concentration. To help, we have drawn an enlarged cordonnet outline for the right wing and provided detailed instructions on how to make it; the left wing is simply a mirror image of the right wing. The cordonnets for the skirt and bodice are straightforward. For the body parts, follow the same methods as outlined earlier – the only difficult part is connecting the hands to the ends of the arms. If you can work through these difficult parts the rest is fairly straightforward and the end result is extremely satisfying.

*Full-size pattern for gold outline*

## You will need

Embroidery hoop,
250mm (10in)
Needlelace pad(s)
Dupion silk, 350mm
(14in) square
Lightweight calico, 350mm (14in)
square
Medium-weight calico,
350mm (14in) square
100/3 embroidery silk
Sewing thread
No. 9 embroidery needle
No. 9 sharps needle
Dressmakers' pins
Scissors
Fabric paint and
small paintbrush
Tracing paper
Pencil
Gold gel pen
PVA glue
Thin card
White felt for padding
Toy stuffing
Tweezers
Paper-covered wire
Fine copper wire
Gold-coloured metallic thread
Gold stars

# Needlelace

### Wings

The wings are the first element to be attached to the figure, so you should begin by making these. The instructions for making the cordonnet for the fairy's wings are given on page 44. To start the needlelace, begin with a row of buttonhole stitches across the top of the shape and work a couple of rows. When you get to the hole, work down the wing on the left-hand side until you reach the bottom edge of the hole. Work a straight line across to the right-hand side of the wing, and then go back up on the right-hand side until you come level with the top of the hole. You can then continue working down the shape in the normal way. Finish with top stitching around the outside of the wing, the purple area inside the wing and the hole.

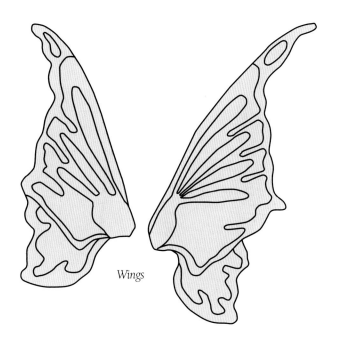

*Wings*

### Clothes

It is better to make the fairy's clothes after you have completed the padding on her body (step 11 in the project). You can then make sure the patterns provided are the right size for your embroidery and adapt them if necessary.

Make the bodice and skirt using corded single Brussels stitch in colours of your choice. Take note of the direction of working. Use top stitching around the neckline and the hem of the skirt. Incorporate a length of fine copper wire into the hem of the skirt so that it can be bent into shape.

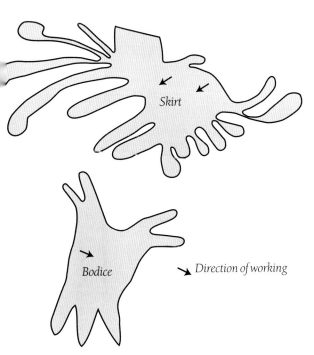

*Skirt*

*Bodice*    ↘ *Direction of working*

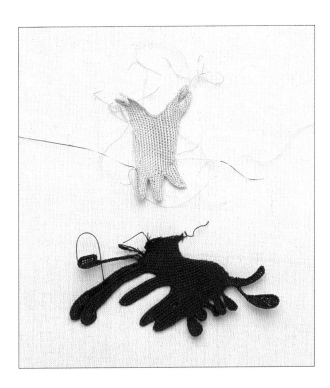

43

# Making the cordonnet for the fairy's wing

> Direction of couching with two threads

<> Single thread one way, two threads on the way back

↘ Direction of working

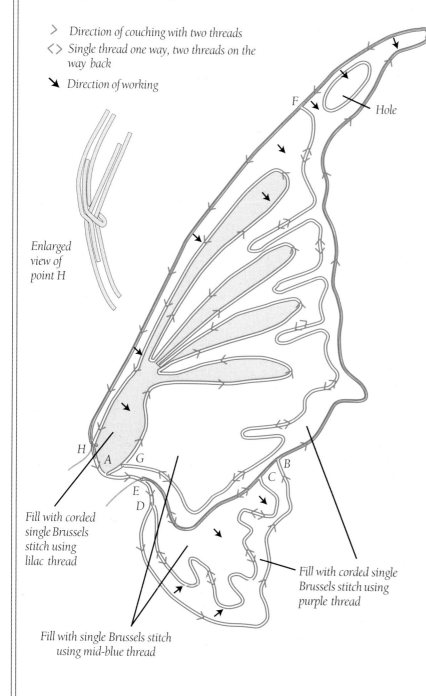

Enlarged view of point H

*Fill with corded single Brussels stitch using lilac thread*

*Fill with single Brussels stitch using mid-blue thread*

*Fill with corded single Brussels stitch using purple thread*

Hole

The cordonnet for the fairy's wing may seem complicated, but the basic rules apply. Two unbroken threads are couched down around the design to support the filling stitches. A fine copper wire is added to the outside edge to enable the top of the wing to be bent away from the background fabric.

Start with a loop at A. One side of the loop will need to be twice as long as the other. Couch down in the direction of the arrows around the lilac-coloured central pattern back to A. When you get to A, using a small crochet hook or a large-eyed needle, take one thread through the loop you started with. Continue around the bottom of the wing, following the arrows to B. At B take one thread to C. At C take the single thread round clockwise to D, then back again to C. Remember to couch down the single thread with a few stitches to hold it in place, and to couch down normally on the way back over both threads.

When you get back to C take your single thread round to E. At E add a fine copper wire (leave a tail of 50mm, or 2in) as you couch both threads back to B. At B pick up the other thread you left behind and couch both threads and the brass wire round to F. At F take one of the threads round to G, couching down in a number of places to hold it in position. At G return to F, couching down both threads. When you get back to F pick up the thread and the brass wire and couch down to H. At H follow the enlarged diagram to finish the cordonnet. Leave 20mm (¾in) of the brass wire as a tail to be sewn down later. The hole at the top is a normal cordonnet.

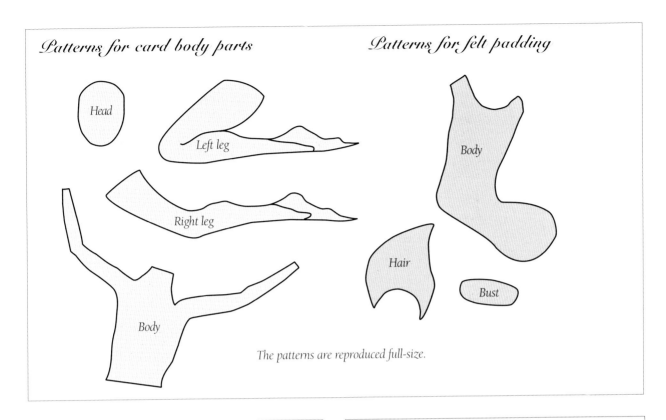

## Patterns for card body parts

Head

Left leg

Right leg

Body

## Patterns for felt padding

Body

Hair

Bust

*The patterns are reproduced full-size.*

### Tip
When you are tracing the pattern, make sure you transfer the outline only – not the details.

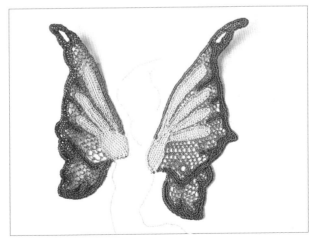

1. Begin by tracing the pattern for the fairy on to the dupion using gold gel pen. Place the fabric in the hoop with a backing of medium-weight calico and tighten the hoop so that the fabric is taut. Make sure the pattern is positioned centrally in the hoop.

2. Attach the wings to the background fabric using stab stitch. Attach only the inner part of the wing; raise the outer parts so that they stand away from the background, giving a three-dimensional feel to the image.

 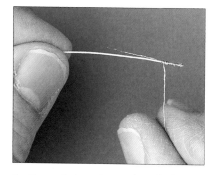 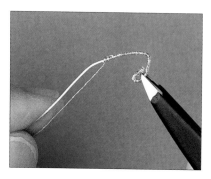

3. Make the two legs using the patterns on page 45. Follow the instructions provided on page 27. On each leg, draw on the outline of the shoe lightly in pencil, and then paint the shoe on using fabric paint and a small paintbrush.

4. For each shoe decoration, dip the end of a length of fine paper-covered wire into PVA glue. Before the glue has time to dry, take a length of gold-coloured metallic thread and wind it tightly round the end of the wire. Secure the thread, leaving a long end with which to attach the decoration to the shoe.

5. Coil the end of each decoration by holding it firmly in a pair of tweezers and forming it into the correct shape.

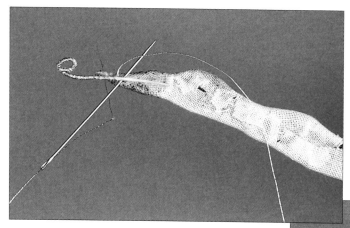

6. Attach a decoration to the back of each shoe, sewing it in place using the long end of the gold thread.

7. Make the body using the pattern provided on page 45. Overlap the calico at the ends of the arms, leaving 5mm (¼in) without any card backing. This end is used to wrap around the wrists to give a neat transition from the calico arm to the wired hands. Make the two hands following the instructions on pages 34–35.

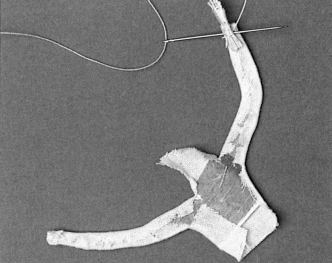

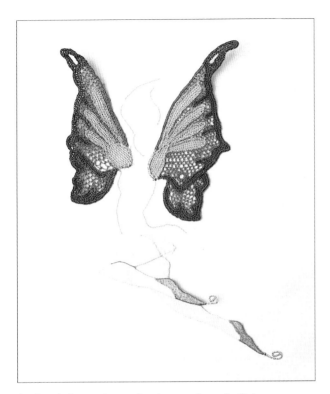

8. Attach the two legs to the picture using stab stitch.

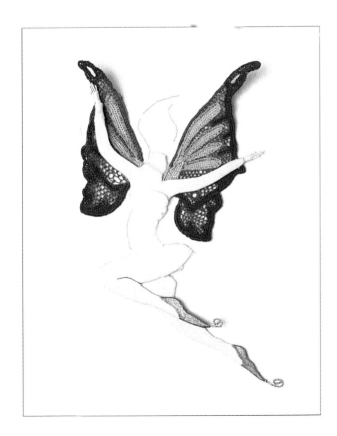

9. Attach the body to the picture using stab stitch. Cut out a piece of felt padding for the fairy's bust using the pattern on page 45, and sew it in place.

10. Cut out the felt padding for the fairy's body and attach it to the background fabric. Use stab stitch.

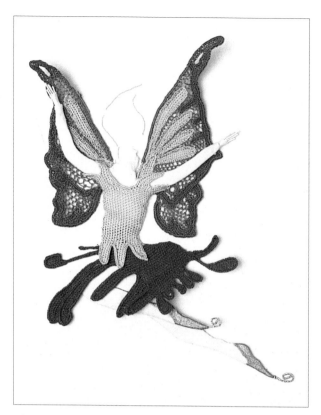

11. Attach the fairy's skirt and bodice using the long threads left on the needlelace.

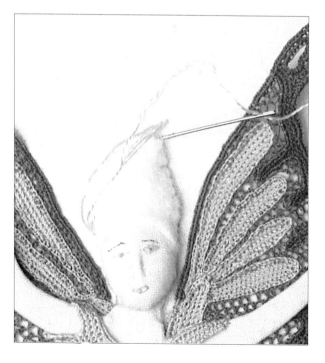

12. Make the fairy's face following the techniques described on pages 28–29 and attach it to the picture. Cut out and attach the felt padding for the hair.

13. Using a single strand of cotton and an embroidery needle, construct the hair using long satin stitch.

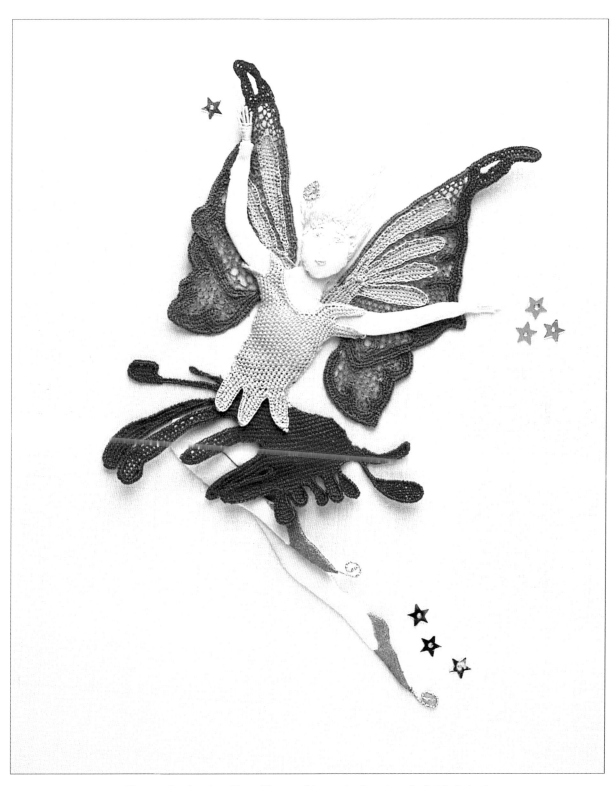

*The completed project. The gold stars add a touch of magic to the finished piece!*

# Gone Fishing

This delightful picture was inspired by Kay's dad who, during his lifetime, loved fishing. To make the picture more appealing we have made the figure into a young boy.

The foreground leaves of the bulrushes and all of the boy's clothing are made of needlelace, except for the boy's shoes which are made of leather. The filling stitch used in the needlelace is corded single Brussels stitch. Satin stitch is used for the boy's hair and over interfacing for the background leaves of the bulrushes. The bulrush heads are made using turkey knot stitch and the stems are worked in raised stem band stitch. The worm escaping from the tin can is a single drizzle stitch, and the water is a piece of fine silk chiffon painted the same colour as the background fabric.

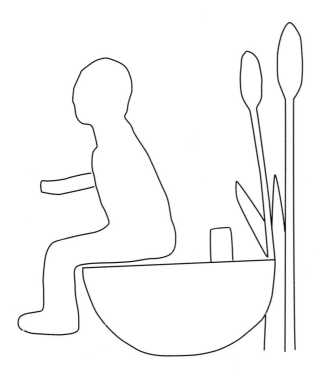

*Full-size pattern for gold outline*

## You will need

Embroidery hoop,
250mm (10in)
Two silk frames
Needlelace pad(s)
Lightweight calico,
300mm (12in) square
Medium-weight calico, 300mm
(12in) square
Silk chiffon, 100 x 200mm
(4 x 8in)
Stranded cotton or 100/3
embroidery silk
Sewing thread
No. 9 embroidery needle
No. 9 sharps needle
No. 10 ballpoint needle
Dressmakers' pins
Scissors
Fabric paint and
large paintbrush
Blue acrylic paint
Tracing paper
Pencil
Gold gel pen
PVA glue
Superglue
Thin card
Felt for the padding
Toy stuffing
Thin copper wire

*For the shoes:*
Gloving leather
Black cotton thread

*For the boat and the float:*
5mm (¼in) balsa wood
Wood veneer

*For the rod and line:*
Cocktail stick
3mm (⅛in) wooden dowel or
a button
Thin fishing line

*For the tin can:*
Foil

# Making the body parts and padding

Before you begin to construct the fisherman, make all the card body parts and put them to one side ready to incorporate into your picture. Use the templates below to make the head and two legs, and cut two layers of padding for the body, one for the right arm and one for the hair.

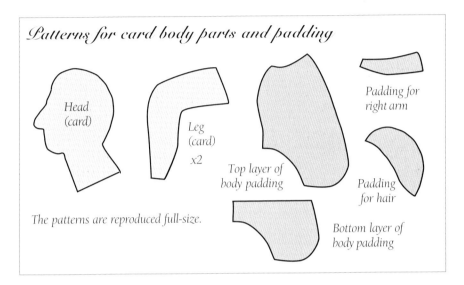

**Patterns for card body parts and padding**

Head (card)

Leg (card) x2

Top layer of body padding

Padding for right arm

Padding for hair

Bottom layer of body padding

*The patterns are reproduced full-size.*

# Making the clothes

It is advisable to wait until step 7 of the project, when all the padding, the right arm and the right leg are in place, before making the clothes. You can then check that the patterns provided are the right size for your fisherman, and adjust them if necessary. You will, however, need to make one of the socks early on and sew it to the right leg before attaching the leg to the background (step 3).

The fisherman's shirt, shorts, cap and socks are made of needlelace, and his shoes are made of leather. Trace the pattern for the shoes on to tracing paper and cut it out. Use this as a template to cut two shoe shapes and one reversed shoe shape out of gloving leather. One of these will be used for the right foot and two for the left foot, one glued on each side, to give it a three-dimensional appearance.

**Tip**

If you are designing clothes for a stumpwork figure, think about what they would wear in real life and dress your figure the same way.

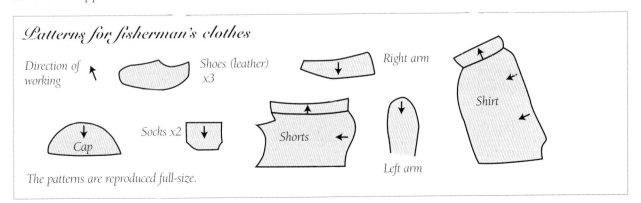

**Patterns for fisherman's clothes**

Direction of working

Shoes (leather) x3

Right arm

Shirt

Cap

Socks x2

Shorts

Left arm

*The patterns are reproduced full-size.*

# Needlelace

Use the patterns on the previous page and follow the notes below to make the cordonnets and the needlelace parts using corded single Brussels stitch. In general, when applying needlelace to a stumpwork design, no top stitching is required prior to releasing the lace from the pad, except where the edges show – in this case the cap edge, the edge of the collar and the waistband and edges of the shorts.

The left arm is freestanding and only the top of the arm is attached to the background. The left sleeve is therefore constructed around the arm before it is attached to the picture, and the instructions for this are given on pages 56–57.

Remember to check the sizes of the patterns before you start working. The patterns provided here are for the parts we made and yours may be different in size or tension. The needlelace parts were all made on a single needlelace pad, though you can make a separate pad for each one. The letters refer to the notes below.

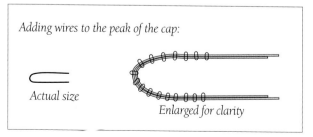

*Adding wires to the peak of the cap:*

*Actual size*

*Enlarged for clarity*

## a. Right sleeve

The right sleeve is worked in corded single Brussels stitch (see page 16). When completed, stab stitch with the same colour thread over the felt padding already applied.

## b. Shirt

The shirt is worked in corded single Brussels stitch. Note the directions of working for the collar and body section. The collar is top stitched on the front edge and bottom only. Turn the collar over before applying it to the background fabric. The shirt is longer than it needs to be so that it can be 'tucked into' the shorts that are then fitted over the top of it.

## c. Socks

The socks are made using corded single Brussels stitch with no top stitching.

## d. Shorts

The shorts are worked in corded single Brussels stitch. Work the bottom part first starting at the back and working down to the leg. Turn the lace round and work the waistband from the bottom to the top. Working this way will give a neat edge to the bottom of the waistband.

Apply top stitching across the top of the waistband and around the leg. Do not stitch the shorts into position until you have completed both legs.

## e. Cap

The main part of the cap is worked in straightforward corded single Brussels stitch and then top stitched along the bottom.

## f. Peak of cap

The peak of the cap is a little complicated. On your needlelace pad lay a fine wire in a U shape and couch it down.

Starting at the tip of the peak, work corded single Brussels stitch across the U shape. Continue for the length you want the peak. We did eight rows. Release the lace from the pad, feed the back wire into the front of the cap and sew off. The other wire will feed into the head at the base of the cap approximately 5mm (¼in) from the front.

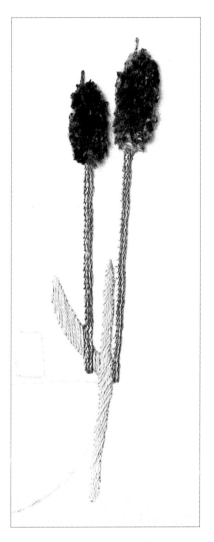

1. Stretch a 300mm (12in) square of fine calico in a silk frame. Dampen the lower part of the calico with clean water, then lay a wash of pale blue and allow it to dry. When laying the wash, allow enough room on the left-hand side for the fisherman's rod. While the paint is mixed, stretch the piece of silk chiffon in another frame and paint it with the same colour blue. This will be the last element you add to your picture.

When the paint is dry, remove the calico from the frame and trace the pattern using the gold gel pen. Place the fabric in the embroidery hoop with a backing of medium-weight calico, and tighten the hoop so that the fabric is taut

2. Work the bulrushes using raised stem band stitch for the stems and turkey knot stitch for the heads. Use two short straight stitches for the top of the bulrush heads. The background leaves are satin stitch over interfacing, which is ideal for recreating the crisp edges of the leaves and helps give the satin stitch a neater appearance. We have painted the interfacing to match the thread colour to minimise the white show-through.

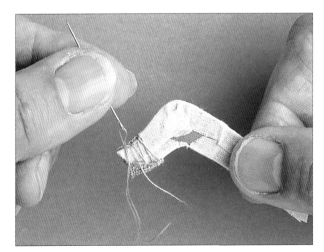

3. Wrap one of the socks around the bottom of the right leg, and lace the two edges together on the back. Attach the other sock to the left leg and put it to one side.

> *Tip*
> When positioning the gold outline on the background fabric, leave enough room to the left of the fisherman for his rod and float.

4. Sew the right leg to the picture using stab stitch. Attach the two layers of padding to the fisherman's body.

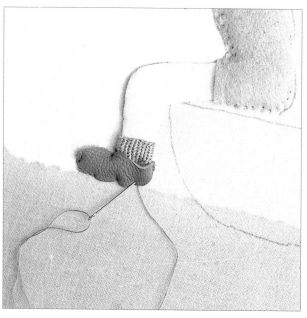

5. Attach the right shoe to the right leg using very small, neat stab stitches. Use a sharp needle to help pierce the leather.

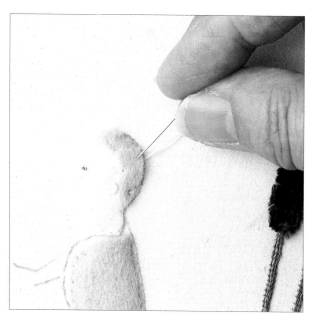

6. Make a head using the pattern on page 51, and sew it to the background fabric (see pages 28–29). Add a layer of padding for the fisherman's hair.

7. Make the right arm and hand following the technique described on pages 34–35. The arm should be as long as the fisherman's shirt sleeve (approximately 20mm, or ¾in, from the wrist to the body). Couch the arm down, as far as the wrist, to the background fabric.

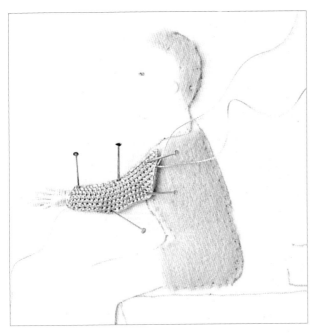

8. Attach a layer of felt padding over the wires and stab stitch it into place, then sew on the fisherman's right sleeve.

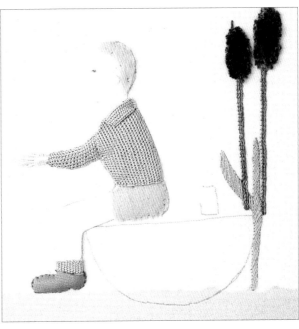

9. Sew on the fisherman's shirt.

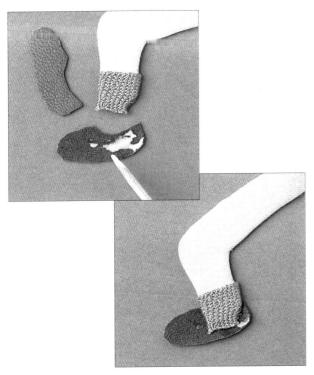

10. Take the left leg and two shoe shapes (one reversed) that you prepared earlier, and glue the reversed shoe shape to the right side of the foot using PVA glue.

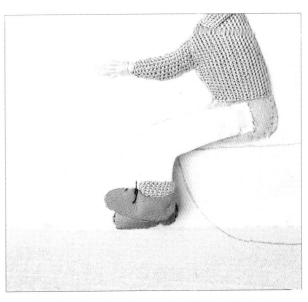

11. Glue the other shoe shape to the left side of the foot to complete the shoe. Thread a short length of black cotton through the top of the shoe and tie it in a knot to make the shoelace. Attach the left leg to the picture using stab stitch. Sew only around the top of the leg, underneath the area covered by the shorts, leaving the rest free to dangle.

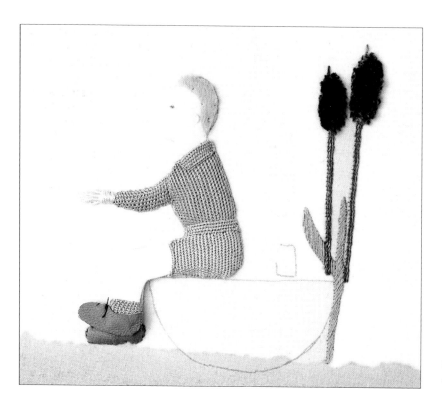

12. Now the left leg is in place the shorts can be stitched on over the leg and the bottom of the shirt.

## Constructing the left arm

First, make a man's hand following the instructions on pages 34–35, leaving tails of wire about 50mm (2in) long. Cut 80mm (3in) strips of non-woven surgical tape and wrap them around the lengths of wire to form the arm, making it slightly fatter at the top than at the wrist. Paint the arm with blue acrylic paint and leave it to dry.

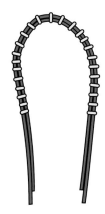

13. Using the pattern on page 51, set up a needlelace pad and couch a 150mm (6in) length of embroidery silk, doubled, on to the pad.

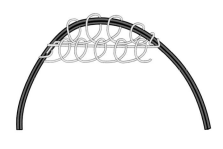

14. Make a foundation row of buttonhole stitches across the top of the cordonnet, and lay the thread back across the row. Make a buttonhole stitch into the first loop of the row above, but *do not pick up the laid thread*. Make the next stitch in the same way, and continue across the row. Repeat for six rows.

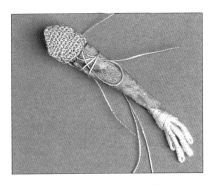

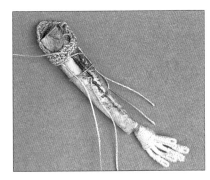

16. Starting at the front of the arm, work one row of buttonhole stitches into the loops of the row above. Continue around the arm, working buttonhole stitches into the two threads that were wound around the arm. After working two or three rows, make sure the arm fits comfortably on to the body of the fisherman. Continue round the arm, working buttonhole stitches into the loops of the previous row, until the needlelace covers the arm.

15. Carefully remove the needlelace from the pad and lay it over the arm so that the needlelace covers the top of the wires. Wrap the needle and thread around the arm twice – this will help to hold the needlelace in place.

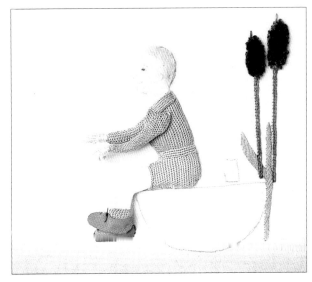

17. Attach the left arm by stab stitching around the top part of the arm only. Carefully bend the fingers round as if they were holding the fishing rod.

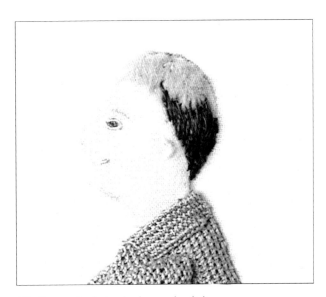

18. Sew on the hair using long satin stitch.

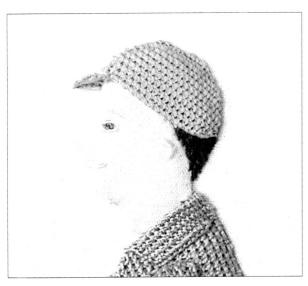

19. Attach the cap then the peak of the cap, as described on page 52.

# Making the fishing rod, reel, line, float, tin can and boat

### The fishing rod

The fishing rod is made from a cocktail stick with the pointed ends cut off.

### The reel

The reel is a 3mm (¹⁄₈in) length of 5mm (¼in) dowel glued with PVA to the cocktail stick. The handle of the reel is a piece of cocktail stick inserted into a hole drilled in the reel.

### The line

For the line we used a 400mm (16in) length of fine fishing line tied to the rod in four places. A small amount of superglue was applied to each knot to stop it from coming undone. The line was hung in loops between each knot.

### The float

The float was cut from balsa wood and painted using acrylic paints.

### The tin can

For the tin can cut a piece of foil 10 x 20mm (½ x ¾in) and bend it to the shape of the can: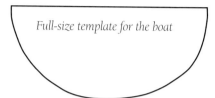

Paint the can in a colour of your choice using acrylic paint. When the paint is dry glue the can in position on the background fabric using PVA glue. The worm is made using drizzle stitch as described on page 21. Bend the worm over the top of the can and secure it with a small dab of PVA glue.

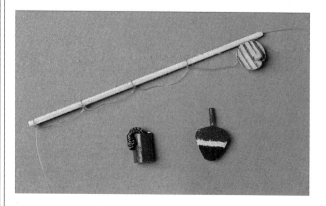

### The boat

To make the boat, cut a piece of 5mm (¼in) balsa wood to the shape of the template below.

*Full-size template for the boat*

Cut a piece of veneer across the grain 5mm (¼in) wide and 100mm (4in) long. The veneer is cut across the grain to make it easier to go round the curve of the boat. Attach the veneer to the curved edge of the boat using PVA glue and hold it in place with your fingers until the glue goes off, or secure it with elastic bands until the glue has set.

*Attaching the veneer to the edge of the boat.*

When the glue is dry trim the top edges flush with the top of the boat. Cut another piece of veneer, this time with the grain, 5mm (¼in) wide and 60mm (2½in) long, and glue it to the top edge of the boat, overlapping the edge on each side. When the glue is dry, trim it flush to the sides of the boat.

Use the boat as a template to cut the veneer for the front of the boat. It doesn't matter if you cut the veneer oversize as it can be sanded back to the correct size later. Glue the veneer to the front of the boat.

*The completed boat.*

## *Needlelace bulrush leaves*

Work each leaf in corded single Brussels stitch. Top stitch around the edge of each leaf but not along the bottom. Add a fine copper wire to the cordonnet as it is couched down so that the leaves can be bent away from the background fabric and moulded into interesting shapes. For each leaf, measure off a length of 100/3 embroidery silk and fold it in half. Cut a single length of fine copper wire, enough to go round the leaf plus 50mm (2in). Start to couch just the thread along the bottom of the leaf, then add in the wire, leaving a 25mm (1in) tail of wire, on the corner. Couch the threads and wire round to the other corner, leave the wire and finish couching the threads along the bottom of the leaf.

*Full-size patterns for the bulrush leaves.*

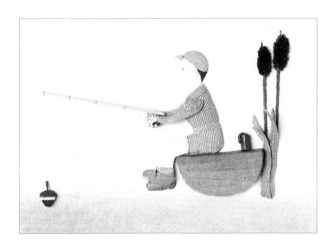

20. Attach the leaves to the background fabric by taking the wires through to the back of your work and sewing them off. Bend the leaves into interesting shapes. Hold the fishing rod in place with a couple of stitches, then arrange the hands so that they look as if they are holding the rod and winding the reel. Position the float so that it appears half submerged in the water and secure it with a stitch around the top. Attach the end of the line to the background fabric, just behind the float, with a spot of PVA glue. Finally, position the boat and the tin can, securing them both with PVA glue.

### Tip
Before completing your picture, you may need to reposition it within the embroidery hoop so that there is enough room to the left of the fisherman for his rod and line.

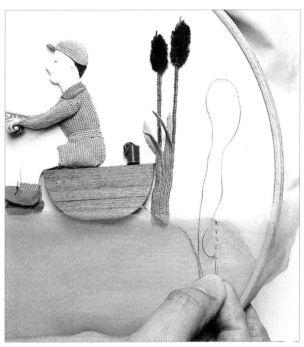

21. Lay the blue-painted chiffon across the bottom of the picture so that it lies over the float and the bottom of the boat but not over the fisherman's shoes. Hold it in place with a few stitches.

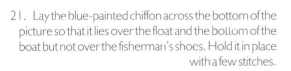

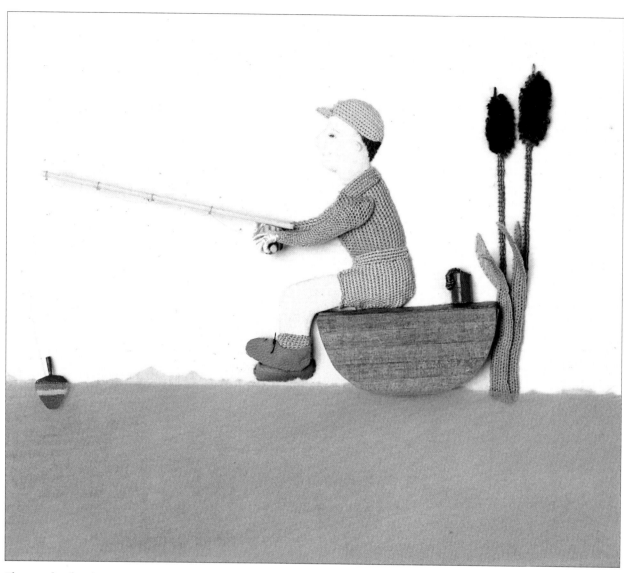

*The completed project.*

# Patterns

On the next three pages are the patterns for the stumpwork embroideries in this book. They are all reproduced full size. From these you can derive patterns for the body parts, padding and clothes.

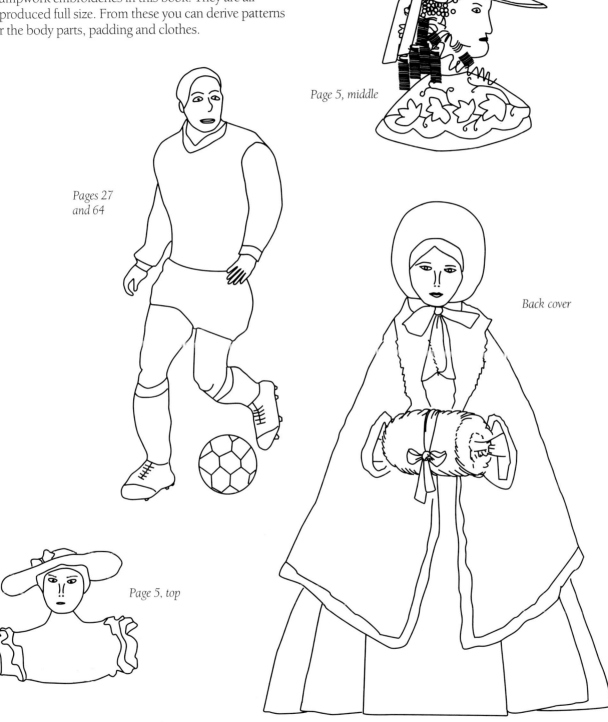

*Page 5, middle*

*Pages 27 and 64*

*Back cover*

*Page 5, top*

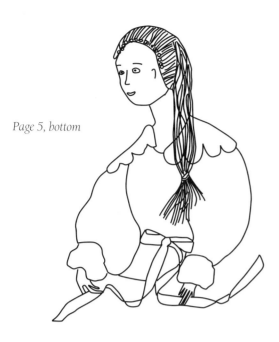

*Page 5, bottom*

*Page 41*

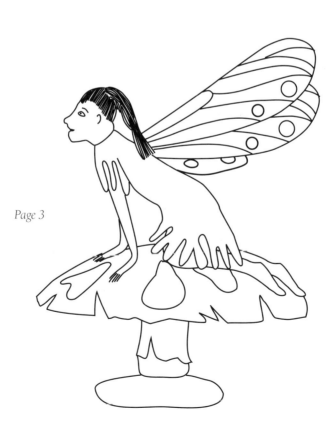

*Page 3*

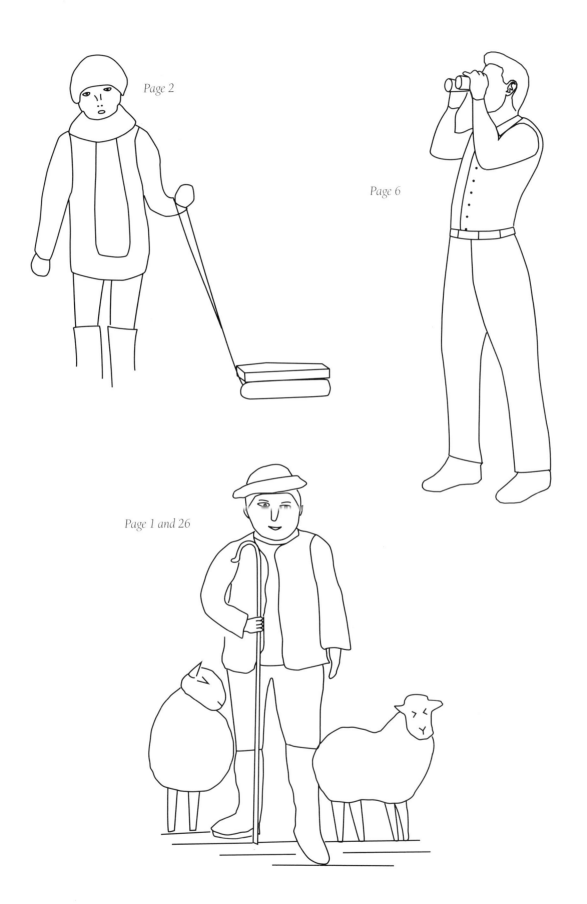

Page 2

Page 6

Page 1 and 26

# Index

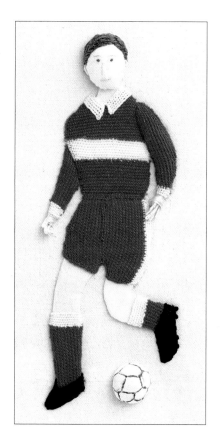